BATTLEFIELD 1

THE ART OF BATTLEFIELD 1

DARK HORSE BOOKS · DICE

DARK HORSE

PRESIDENT AND PUBLISHER
MIKE RICHARDSON

EDITOR
IAN TUCKER

DESIGNER
STEPHEN REICHERT

DIGITAL ART TECHNICIAN
CHRIS HORN

DICE

PROJECT LEADS
ART DIRECTOR GUSTAV TILLEBY • **PRODUCTION ASSISTANT** STEFANA PROZAN • **2D MEDIA MANAGER** VIKTORIA ANSELM • **STUDIO DIRECTOR OF CONTENT** ROBERT RUNESSON • **DIRECTOR OF BUSINESS AFFAIRS** BERNADET BONOMI

CONTRIBUTING ARTISTS
SENIOR CONCEPT ARTIST ROBERT SAMMELIN • **SENIOR CONCEPT ARTIST** ERIC PERSSON • **CONCEPT ARTIST** TAHIR TANIS • **CONCEPT ARTIST** NICHOLAS SHARDLOW • **SENIOR CONCEPT ARTIST** FREJ APPEL • **CONCEPT ARTIST** HENRIK SAHLSTRÖM • **SENIOR CONCEPT ARTIST** PER HAAGENSEN • **CONCEPT ARTIST** MATTIAS HÄGGSTRÖM • **CONCEPT ARTIST** JONATHAN KUO

CAPTIONS
CREATIVE DIRECTOR STEFAN STRANDBERG • **SENIOR CONCEPT ARTIST** ROBERT SAMMELIN • **SENIOR CONCEPT ARTIST** ERIC PERSSON

COVER
SENIOR CONCEPT ARTIST ROBERT SAMMELIN

Special thanks to DICE, including:
Stefana Prozan • Viktoria Anselm • Bernadet Bonomi • Eric Persson • Robert Sammelin

Thanks to the entire Battlefield™ 1 development team for creating an amazing game, and to all of our families for their love and support.

THE ART OF BATTLEFIELD 1
© 2016 Electronic Arts Inc. The DICE logo, Battlefield, Battlefield 1, and the Battlefield 1 logo are trademarks of Electronic Arts Inc. or its subsidiaries. Dark Horse is an authorized Electronic Arts Inc. licensee. Dark Horse Books® and the Dark Horse logo are registered trademarks of Dark Horse Comics, Inc. All rights reserved. No portion of this publication may be reproduced or transmitted, in any form or by any means, without the express written permission of Dark Horse Comics, Inc. Names, characters, places, and incidents featured in this publication either are the product of the author's imagination or are used fictitiously. Any resemblance to actual persons (living or dead), events, institutions, or locales, without satiric intent, is coincidental.

Published by Dark Horse Books
A division of Dark Horse Comics, Inc.
10956 SE Main Street
Milwaukie, OR 97222

DarkHorse.com

To find a comics shop in your area, call the Comic Shop Locator Service toll-free at (888) 266-4226.
International Licensing: (503) 905-2377

ISBN 978-1-50670-228-5
First edition: October 2016

10 9 8 7 6 5 4 3 2 1
Printed in the United States of America

NEIL HANKERSON **EXECUTIVE VICE PRESIDENT** • TOM WEDDLE **CHIEF FINANCIAL OFFICER** • RANDY STRADLEY **VICE PRESIDENT OF PUBLISHING** • MICHAEL MARTENS **VICE PRESIDENT OF BOOK TRADE SALES** • MATT PARKINSON **VICE PRESIDENT OF MARKETING** • DAVID SCROGGY **VICE PRESIDENT OF PRODUCT DEVELOPMENT** • DALE LaFOUNTAIN **VICE PRESIDENT OF INFORMATION TECHNOLOGY** • CARA NIECE **VICE PRESIDENT OF PRODUCTION AND SCHEDULING** • NICK McWHORTER **VICE PRESIDENT OF MEDIA LICENSING** • KEN LIZZI **GENERAL COUNSEL** • DAVE MARSHALL **EDITOR IN CHIEF** • DAVEY ESTRADA **EDITORIAL DIRECTOR** • SCOTT ALLIE **EXECUTIVE SENIOR EDITOR** • CHRIS WARNER **SENIOR BOOKS EDITOR** • CARY GRAZZINI **DIRECTOR OF SPECIALTY PROJECTS** • LIA RIBACCHI **ART DIRECTOR** • VANESSA TODD **DIRECTOR OF PRINT PURCHASING** • MATT DRYER **DIRECTOR OF DIGITAL ART AND PREPRESS** • MARK BERNARDI **DIRECTOR OF DIGITAL PUBLISHING** • SARAH ROBERTSON **DIRECTOR OF PRODUCT SALES** • MICHAEL GOMBOS **DIRECTOR OF INTERNATIONAL PUBLISHING AND LICENSING**

CONTENTS

- 6 FOREWORD
- 8 **CHAPTER ONE** EXPLORATION
- 54 **CHAPTER TWO** THEATERS OF BATTLE
- 154 **CHAPTER THREE** KEY ART

FOREWORD

Taking on the challenge of depicting the Great War in a way never seen before was daunting. It affected us profoundly, and we found as we worked that our own preconceptions of the war began to change.

We were humbled by what we discovered when we explored beyond the photographic history of World War I. We journeyed to historical locations, touched authentic hardware, and learned the stories of the events that really took place.

Through this, we saw an opportunity to depict a beautiful world undergoing a massive change—a world being consumed by the first mechanized war.

We wanted to capture the fascinating power in the contrast between this old, romantic world and the new one. Our world as we know it today was born from this conflict one hundred years ago.

Working on *Battlefield 1* has moved all of us who were part of shaping it. Our depiction of these events, and our process of developing that depiction, was both a discovery and a journey.

This book will show you that journey.

—CREATIVE DIRECTOR **STEFAN STRANDBERG**, ART DIRECTOR **GUSTAV TILLEBY**
& CREATOR OF ORIGINAL CONCEPT **MARTIN KOPPARHED**

DISCOVERING THE OPPORTUNITIES OF THE GREAT WAR
EXPLORATION

At the earliest stages of development, the concept team and the creative directors came together to generate hundreds of ideas that formed the genesis of the game we wanted to build. Some concepts never made it past this stage, some led to themes in the final game, and some directly inspired the team to build specific levels, characters, or equipment. This is where the journey started.

Working on a game set in the First World War was a dream come true for many of us at DICE. As we got started, we dove headfirst into documentaries, reference books, and the dark corners of the Internet to find the best reference materials to help us build our take on this world.

We quickly started exploring settings and characters to see what kind of variations we could find in this era. We soon discovered there was an extreme variety in uniforms, gear, and gadgets, all of which changed throughout the four years of the war.

EXPLORATION // CHARACTER DESIGN

EXPLORATION // CHARACTER DESIGN 11

During our research, we found a wide variety of equipment and weapons that we fell in love with. At this stage, we basically gathered all the cool stuff we could find and tried it out in rough sketches. Among our favorites on this spread are the German Gaede steel helmet, the tank-breaching improvised geballte Ladung grenade, and the iconic splatter mask that we would use for the tank drivers. The broad variety of melee weapons we found in our research hinted that there was an opportunity here for combat more brutal than in previous *Battlefield* titles.

EXPLORATION // CHARACTER DESIGN

EXPLORATION // CHARACTER DESIGN 13

Considering that the uniforms of this era would largely be in gray and muted colors by the end of the war, there were many discussions around how we could work with character shapes and silhouettes to distinguish nations and classes from each other. We also had a shape language from earlier *Battlefield* games that we wanted to maintain to make sure that the game would feel familiar to veteran players, even though the setting was new.

14 EXPLORATION // CHARACTER DESIGN

16 EXPLORATION // CHARACTER DESIGN

The next step after the initial sketches was to flesh out some of the ideas in more detail to find a style and tone that fit the vision for the game.

Because these paintings are more specific and leave less open to interpretation, they were really useful in presentation materials to communicate how we intended our characters to look, and we started to get a better understanding of materials and color choices for the different armies.

EXPLORATION // CHARACTER DESIGN

Looking back, these early stages were a really creative time in the project. The concept artists teamed up to toy around with ideas for characters that we would love to see in the game. A lot of good ideas came out of this—some would make it into the game, and some would get discarded.

EXPLORATION // CHARACTER DESIGN

EXPLORATION // CHARACTER DESIGN 19

The German army was at the forefront of inventing new technology and equipment at this time. The German steel helmet that replaced the Pickelhaube in 1916 proved to be the most effective head protection in the war, thanks to the skirt protecting the neck and sides of the head. Other interesting inventions from this time included an extra front plate that was intended to protect against snipers and experimental metal body armor for use by machine gunners. We had to try these out for some of the characters to see where we could use them.

20 EXPLORATION // CHARACTER DESIGN

22 EXPLORATION // CHARACTER DESIGN

EXPLORATION // CHARACTER DESIGN 23

The plan for a long time was to include the French army in multiplayer mode, as they were the biggest forces deployed in the field of the Triple Entente, and it was a disappointment to realize that we didn't have the resources to include them in the base game. Since the UK and US armies wore similar uniforms, we could share equipment between them and get two armies out of one. We decided that it wouldn't pay the French army justice to shoehorn them in next to the other armies. If we were to add them in multiplayer, they needed to get the attention they deserved for their significant involvement in the war.

EXPLORATION // CHARACTER DESIGN

Adapting real equipment and uniforms from the era and trying to make them look cool depended on finding the right posture and attitude for the character. With the French army, we were focusing on the later part of the war, when the uniform colors started to become more muted. We wanted the soldiers to look rugged and experienced, but we also considered some of the earlier colorful clothing, like the traditional Zouave dress.

EXPLORATION // CHARACTER DESIGN

The British Army had a lot of diversity in equipment for us to explore, and we tried many different uniforms for them. Since much of their equipment was similar to the US Army's, we tried to find and emphasize the details that made them distinct from each other. The pilots of World War I had iconic and cool outfits that we loved to make variations of, so we knew early on that we wanted to include different vehicle classes.

EXPLORATION // CHARACTER DESIGN

28 EXPLORATION // CHARACTER DESIGN

The single-player campaign story had a few iterations before we ended up with the short stories we decided on for the final product. During these iterations, we explored a variety of characters and settings, some of which can be seen here. Story-driven moments are really fun to brainstorm, since they generally give the team an opportunity to explore more adventurous themes and events.

EXPLORATION // CHARACTER DESIGN 31

These are some of the earliest concepts we made for the game. We were exploring the scenarios that could be played out in this era and setting and made inspirational artwork to support these ideas. We wanted to capture the variety in scenery and theme that this setting would offer to make sure that everyone would understand the opportunity we would have if we decided to make this the next big *Battlefield* game.

EXPLORATION // ENVIRONMENTS

34 EXPLORATION // ENVIRONMENTS

EXPLORATION // ENVIRONMENTS

36 EXPLORATION // ENVIRONMENTS

Some of these ideas came off the top of our heads, but for others, we considered a kind of rock-paper-scissors game play to put two opposing themes together in one image. What would a sniper-versus-airplane scene look like? How about flamethrower versus motorcycle, or dynamite versus tank? These themes got us started and communicated much more clearly what we intended to do with the game.

EXPLORATION // ENVIRONMENTS 37

The intention was also to set these events in environments that we wanted to build for the game. The French chateau was one of these early ideas that we had never seen in a shooter game before, and it really captured the unique look and feel of the era that we wanted. In the end it also proved to be one of the most defining levels included in the game.

EXPLORATION // ENVIRONMENTS 39

Where the Western Front was concerned, we really wanted to fulfill people's expectations of the nightmares that would take place in these trenches. We explored extremely dark visuals and themes, like brutal melee combat and powerful tanks. It was quite a challenge to make sure we included this in our game without taking it too far or making it dull and one sided. When we explored contrasting this darkness with an idyllic landscape and beautiful lighting, it really opened up something visually interesting.

EXPLORATION // ENVIRONMENTS

There was also an opportunity to make some epic sea battles. The Battle of Jutland was the biggest clash of naval forces during the war and included battleships, cruisers, destroyers, and other military craft. Submarines also had a huge impact during this time, so that was another theme worth exploring.

EXPLORATION // ENVIRONMENTS 45

Adding flamethrowers and gasoline to the game was something that almost everyone in the development team was excited about. We had a lot of ideas about the flamethrower guy, but one we were really fond of was to include him in a boss battle where the player would have limited firepower and must silently navigate a maze of trenches to be able to shoot him in the back.

46　EXPLORATION // ENVIRONMENTS

EXPLORATION // ENVIRONMENTS

The idea of making a forest level met with some resistance and healthy skepticism at first, mainly because of the technical challenges involved and the difficulty of figuring out how much destruction we would be able to incorporate in that scenery while still making sure that the level played smoothly. Also, snowy levels like the Dolomite Alps and the Eastern Front were explored to see what themes we could include in those environments.

EXPLORATION // ENVIRONMENTS

EXPLORATION // ENVIRONMENTS

The Middle Eastern campaign was important to include very early when presenting the idea for this game to make sure that we could offer enough variety for a blockbuster title in the First World War setting. We were looking into what opportunities we could explore with settings like the Sinai Desert, Mesopotamia, and of course Gallipoli. The Hejaz Railway played a pivotal role in the war, so it was interesting to look into game play opportunities involving the train.

EXPLORATION // ENVIRONMENTS

EXPLORATION // ENVIRONMENTS

52 EXPLORATION // ENVIRONMENTS

EXPLORATION // ENVIRONMENTS 53

A GLOBAL WAR
THEATERS OF BATTLE

As work continued, we began to identify the ideas and concepts that would define the finished game. At this point, we knew that this was the right game to build; we just had to narrow down the specifics of each level to make sure that we were offering visual variety as well as interesting themes for a new generation of first-person shooters.

GOING BEYOND HELL
THE WESTERN FRONT

The London airship level was something we made early in development to examine how we could make airplane game play fun and exciting. The theme for the level was inspired by reading about bomb raids that were made over London starting in 1915, and much of the look for the level came from an early mood concept image that showed airplanes fighting in the clouds at sunset.

THEATERS // THE WESTERN FRONT

THEATERS // THE WESTERN FRONT

THEATERS // THE WESTERN FRONT 59

A lot of effort went into completing paint-overs of the airship interior. We tried to stay close to reference but had to take liberties with the layout of walkways, gas cells, and other features for game play reasons. We also wanted to make sure that it didn't end up feeling too much like a closed, isolated space, so we decided to rip open the airship hull to let in more light, showing the player the vast outside landscape and giving a feel for the danger of the situation.

THEATERS // THE WESTERN FRONT 61

This level was inspired by the German Spring Offensive of 1918, where their infantry almost reached the city of Amiens, a key point for the Germans to capture. Their initial success was halted, and they never actually reached the city, but we wanted this as a continuation from the St. Quentin "Scar" map—going beyond the trenches into open land, toward the magnificent city. We wanted to capture some of the lesser-known urban combat that took place during the war. It was key for delivering game play variety—a city level with close-quarters combat interiors and vehicle combat on the open streets.

62 THEATERS // THE WESTERN FRONT

THEATERS // THE WESTERN FRONT 63

64 THEATERS // THE WESTERN FRONT

THEATERS // THE WESTERN FRONT 65

66 THEATERS // THE WESTERN FRONT

THEATERS // THE WESTERN FRONT 67

THEATERS // THE WESTERN FRONT

THEATERS // THE WESTERN FRONT 69

ALLIED FORCES // THE UNITED STATES OF AMERICA

ASSAULT

SUPPORT

MEDIC

SCOUT

The American and the British armies had some similarities in their uniforms, so we decided to give them the same base uniform with different gear on top of it. During the four years of World War I, there were more technical advancements than in any other war in the same time frame throughout history, and we really wanted to include some of the crazy experimental armor and weapons that were developed during this time. Here, we added the American experimental Model 8 helmet to the Support class.

THEATERS // THE WESTERN FRONT

THEATERS // THE WESTERN FRONT 71

To find the right reference, we traveled to France and visited some iconic locations to see what we could use in the game. We took amazing photos during the trip, which made it easier to identify features and fixes that we needed to address in the game. The development of the map required some back and forth, but it ended up looking like a believable space thanks to our talented world-building team.

THEATERS // THE WESTERN FRONT

THEATERS // THE WESTERN FRONT

We spent lots of time generating believable artwork for the different framed paintings. We were inspired by portraits and landscapes from the eighteenth century onward and used these to add verisimilitude to the environments. These were fun for the artists and also helped to identify the maps in which they were used.

74 THEATERS // THE WESTERN FRONT

The tank plowing through the chateau walls was an early idea that we felt captured the contrasting elements of the old and new worlds, and we realized that a level like that had the potential to feel very unique. From there, we started exploring themes that could tie into the chateau, like a luxurious garden, animal statues, and the landscape of the French countryside.

THEATERS // THE WESTERN FRONT

78 THEATERS // THE WESTERN FRONT

NOUS DÉFENDRONS LE PRÉCIEUX JOYAU DE LA LIBERTÉ

Le tambour bat, le clairon sonne;

Qui reste en arrière?...Personne!

C'est un peuple qui se defend.

En avant!

AIDERONS-NOUS A ECRASER LA TYRANNE?

Adressez-vous au Bureau de Recrutement

LES HÉROS

Oui, le carnage est hideux

Oui, le progrès recule et se débat;

Notre siècle furieux retourne au Moyen-Âge,

Mais sachons nous battre au moins

avec courage.

SUIVRONS-NOUS LEUR EXEMPLE?

Adressez-vous au Bureau de Recrutement

FRANÇAIS

souscrivez au

DEUXIÈME EMPRUNT DE LA DÉFENSE NATIONALE

vous hâterez la victorie
et vous aurez
fait votre devoir envers la

PATRIE

Pour que la France

soit Victorieuse!

SOUSCRIVEZ POUR LA VICTOIRE ET POUR LE TRIOMPHE DE LA LIBERTÉ

LIGUE NATIONALE ANTI AUSTRO-ALLEMANDE

Un dernier effort et on les aura

To help make *Battlefield 1* a unique experience, we wanted to include our own take on propaganda from the era. We examined actual military advertisements and tried to make artwork that captured the same feeling.

Our art added believability to the levels once we had it up on the walls in the game, and some people in our team actually mistook some of it for real-world propaganda, which was great feedback for us to hear.

FRANÇAIS!

SOUSCRIVEZ TOUS À L'EMPRUNT

POUR LA DÉFENSE NATIONALE!

JE MANGE PEU ET TRAVAILLE BEAUCOUP!

NE-PAS-GASPILLER-LE-PAIN EST-NOTRE-DEVOIR

THEATERS // THE WESTERN FRONT | 79

80 THEATERS // THE WESTERN FRONT

THEATERS // THE WESTERN FRONT 81

TAIZE

LA FRAÎCHEUR DES BOISSONS

Devenue Morcelé
Une Nouvelle Boisson Pour Un Nouveau Monde

PIED SUPPLÉMENTAIRE

Faites vite!
Cycle autour!

PEINTURE DÉCORATION
A FACON
RAVALEMENTS · VITRERIE
J. GIRAUD
COULEURS · VERNIS
PAPIERS-PEINTS · ARTICLES de MÉNAGE
Rue Dusevel

SAVON DE LA ROSE

VENTE EN BOITES DE 5 K^os

POUR PROVISION DE MÉNAGE

BARON FILS BRITON

EXIGER LA VRAIE MARQUE

SAVON **Flore** POUR LA BEAUTÉ

d'ALBOURG

AU PRINTEMPS

LUNDI 6 JUILLET

VENTE ANNUELLE AVANT INVENTAIRE

RABAIS CONSIDÉRABLES

CENTRAL POWERS // THE GERMAN EMPIRE

ASSAULT

SUPPORT

MEDIC

SCOUT

The German army had very similar uniforms to the Austro-Hungarian army, so—like we did with the UK and US armies—we decided to let them share the same base poniform and find gear and color variations to separate them from each other instead of generating entirely new uniforms. We also wanted to distinguish them from the Italian and British forces that they would be fighting. We tried to separate them with color, but it wasn't really clear enough in the play tests. Instead we tried to separate them with shade values so that the Germans and Austro-Hungarians would always look darker, and the armies they were fighting would always look brighter. Some color accents also had to be exaggerated to communicate more clearly whether it's a friend or foe you see on the battlefield.

84　THEATERS // THE WESTERN FRONT

FLAMETHROWER

CAVALRY

The flamethrower special kit was something we started exploring very early. We really wanted it to stand out from the gas masks that all characters can put on during game play, so we looked at the smoke helmets used mainly by firefighters in this era and found a couple that we really loved. The one in these concepts was by far the coolest and most intimidating one we could find.

86 | THEATERS // THE WESTERN FRONT

88 THEATERS // THE WESTERN FRONT

Both deep forests and trains were key to capturing the fighting in the Argonne area. An early idea for the forest level was to include a derailed civilian train with train cars scattered in the environment, and an early concept portrayed how this could feel while playing the level. Everybody got hooked on the idea, so we added it to the level and tested it early on to see how the placement of the train cars felt. It's interesting to see how close we ended up to the initial concept in the level.

THEATERS // THE WESTERN FRONT

THEATERS // THE WESTERN FRONT 91

The Argonne forest is an iconic location of the Great War, but the Forest of Dean in western England heavily inspired the look for the in-game forest. We had never done a level with a dense forest like this in a *Battlefield* game before, so there were a number of challenges for the team to figure out. We really wanted the forest to feel vibrant and beautiful, and we put a lot of work into detailed paint-overs to nudge the look of the level in the right direction.

92 THEATERS // THE WESTERN FRONT

We wanted the presence of war to have the right balance in this level, so we discussed whether to have the church ruins be bombed out or abandoned and overgrown. In the end, we decided that the latter would give it a flavor more suited to the level, so that's what we went with. Both multiplayer and single-player opportunities were taken into account when developing this level. An early idea was to make a fast-paced driving and shooting sequence for a single-player mission to give some game play variety, but it never came to fruition.

THEATERS // THE WESTERN FRONT 93

THEATERS // THE WESTERN FRONT

THEATERS // THE WESTERN FRONT 95

The first thing that comes to mind for many people when thinking of World War I is the horrific trench warfare, and we knew that this was something we had to challenge while also including it in our game. These early ideas resulted in the level "Scar," where about half of the level fulfills the idea of the dark trenches and muddy no man's land and the other half shows a serene, almost untouched French village on the outskirts of Amiens. There was something interesting in early concepts where these two contrasts were captured in the same image, and we really wanted this to be something you could experience in the game. It was a big challenge to make the transition between the two areas feel both believable and dramatic.

THEATERS // THE WESTERN FRONT

Another challenge in this level—and a challenge when designing video games in general—was to make sure that the village felt like a real place. To achieve this, we worked closely with the level team, not only doing paint-overs but looking at reference together and discussing which details we needed to capture to make these spaces feel more believable.

THEATERS // THE WESTERN FRONT

98　THEATERS // THE WESTERN FRONT

Before completing each level, we created a visual mood board with the art director where we gathered reference for skies, landscapes, color palettes, and themes that we wanted to include. This gave us a good overview of our maps where we could see if they had enough variety to feel different from each other. We would then refer to these mood boards when doing our concepts to make sure they followed the look we wanted.

THEATERS // THE WESTERN FRONT

Different themes were explored to see what visual flavor we could give to this level. The crashed bomber plane in no man's land remains a favorite, and it's a shame that we never found a suitable place for it in the level.

100 THEATERS // THE WESTERN FRONT

Sometimes, we helped the 3D Art department by supplying ideas for what individual art assets could look like. Here, they needed some suggestions for ruins and micro-destruction in interior walls, so we looked at the geometry in the level and painted on top of screenshots to come up with something that could help. Doing concept art for a game like this is a collaborative effort.

THEATERS // THE WESTERN FRONT

102 THEATERS // THE WESTERN FRONT

Toxic gas was one of the themes that felt unique to the setting while also providing game play opportunities to explore. We tried to employ the gas in several different ways, but none was as impactful as the first play test, in which the player witnessed a grenade tumbling down the stairs in an underground bunker, plumes of gas filled the narrow tunnels, and masked soldiers came rushing in to finish off survivors. It was intimidating, to say the least.

EDWARDS

TOWNSEND

MCMANUS

FINCH

PRITCHARD

For the tank crew in single-player, we considered having the characters dress in lighter clothing because of the unbearable heat inside a tank. However, with six armies and single-player missions with dozens of different characters, we were already making more characters than ever before in this game, so we decided to reuse uniforms and clothing from other characters to save some work for our character artists.

104 THEATERS // THE WESTERN FRONT

The tank mission was an early level of focus to prove our tank game play. An early part of the mission functions as a power fantasy involving plowing through enemy lines. For us, it was also an opportunity to prove the visual quality of the game. We painted over screenshots of the game to fix problems and direct the player with visual guides, such as placement of objects and layering of light.

THEATERS // THE WESTERN FRONT

THEATERS // THE WESTERN FRONT 107

AMONG PEAKS OF KINGS
THE ITALIAN FRONT

The Italian coast level was inspired by the beautiful landscape around Garda Lake in northern Italy and takes place along the Adriatic Coast. There were a few themes that we wanted to capture in this level, one of them being the old castle on the hilltop. These castles can be seen all over northern Italy, so we looked at some of them to use as inspiration to help us build something of our own that looked believable.

THEATERS // THE ITALIAN FRONT

ALLIED FORCES // THE ITALIAN EMPIRE

ASSAULT

SUPPORT

MEDIC

SCOUT

The Italian army had a unique look. We really loved the capes they were wearing in the reference we found, so we tried to use cloth for all the characters. We used iconic gear where we could, like the ear protection and the Adrian helmet with Dunand visor.

110 THEATERS // THE ITALIAN FRONT

During two reference trips to Italy, we gathered plenty of material and inspiration for making this level as good as it could possibly be. This was the first level where we tried to incorporate the dreadnought behemoth, and it proved to be a really compelling addition to the game in our early play tests. We also had some interesting opportunities for close-quarters combat in small Italian villages, something that we couldn't remember ever seeing in a video game like this before.

THEATERS // THE ITALIAN FRONT

THEATERS // THE ITALIAN FRONT

We started this level by completing some quick and loose paintings of features that we wanted to include. The change in verticality was originally more exaggerated, but while it added a nice visual identity, it didn't make sense for the overall design. In the end, we managed to achieve something similar while still ensuring that the level was playable. We found several castles in northern Italy that served as inspiration for the scenery in this level.

THEATERS // THE ITALIAN FRONT

THEATERS // THE ITALIAN FRONT 115

CENTRAL POWERS // THE AUSTRO-HUNGARIAN EMPIRE

ASSAULT

SUPPORT

MEDIC

SCOUT

The Austro-Hungarian army was tricky at first, since it was difficult to find good reference. Visiting museums for inspiration helped; for example, the Assault helmet protection was sourced from a local museum. We also improvised with some details, like the helmet from this era (which we also saw in a museum) that was originally used for something else but really fit our Support class, so we decided to use it there.

THEATERS // THE ITALIAN FRONT

ANTI-VEHICLE

CENTRAL TANK DRIVER

CENTRAL PILOT

Designing the Anti-vehicle special class was a bit of a stretch when balancing realism and fiction, but his gear was based on real goggles and breathing masks that existed during the war. We shrouded him in a simple hood that he'd use to blend into the environment, but we also looked at some primitive ghillie suits from the era that were mostly improvised. The tank drivers of the time would wear splatter masks made of leather and metal to protect their faces from shrapnel; they had such a cool look that we had to make sure to include them in the game.

THEATERS // THE ITALIAN FRONT

This level was the first one we built for this game, so there were a lot of things to get right from the art, audio, and design perspectives. We tried different things with the environment visually but didn't quite get it right until our trip to the Italian Dolomites, where we got amazing reference that steered us in the right direction. This region is filled with trenches and fortresses from the Great War, and seeing them in person helped us make it feel like a believable place. We modified the terrain a bit and had to scale the whole space down to make it less of a marathon for infantry to run through it, but I think we found a good balance between scale and distance.

THEATERS // THE ITALIAN FRONT

THEATERS // THE ITALIAN FRONT 121

We were exploring dynamic weather while working on this map, so we made quite a few variations for different weather conditions. We were also exploring the theme of day cycles during "Breakthrough," where tanks and other attackers would have moved up through the sectors together, all visible elsewhere in the environment. Unfortunately, it meant too much work for too little payoff, and the players would devastate the landscape on their own anyway, so we left that idea behind pretty quickly.

THEATERS // THE ITALIAN FRONT

126 THEATERS // THE ITALIAN FRONT

Another idea we discussed was to have cinematic introductions in "Breakthrough" where we'd add a bit of visual narrative before you could start playing. For this level, it would have been artillery fire raining down in the landscape before the player started rushing in. However, this would only have been shown for players that are in the game from the start, and not for anyone joining in the middle of a session, so it would mean more work for us and—again—not a huge payoff for the player. Instead we decided to add the narrative in the form of a short introduction film that would be shown to everyone joining the game.

THEATERS // THE ITALIAN FRONT

SECRETS BENEATH THE SAND

THE MIDDLE EASTERN FRONT

The Middle East was something we wanted to include to provide the game with some thematic variation, and to emphasize the feeling that this was the first truly global war. We started building the Sinai Desert level after a reference trip to Jordan, where we captured some really great material to get the right feel for these environments.

THEATERS // THE MIDDLE EASTERN FRONT

It took several attempts to find the right look for the desert village. We experienced difficulty balancing the colors—all of the buildings were blending into the sand, making them disappear among the sand dunes. It took several iterations before we arrived at the white paint, colored window shutters, colorful carpets, and other decorations that we used to highlight the buildings.

THEATERS // THE MIDDLE EASTERN FRONT 131

CENTRAL POWERS // THE OTTOMAN EMPIRE

ASSAULT

SUPPORT

MEDIC

SCOUT

The Ottoman army had a lot of different looks and uniforms, and we had to take some liberties with them. The reference we found showed them wearing khaki uniforms, but that would have made them look too much like our British Army. Instead, we decided to make them bright by giving them red accent colors so they could be easily distinguished from the British. They also had some German equipment, which grouped them visually with their allies.

132　THEATERS // THE MIDDLE EASTERN FRONT

BEDOUIN REBEL

LAWRENCE

These are character explorations for the single-player episode "Nothing Is Written," the episode that was constantly ridiculed because—literally—nothing was written until fairly late in production. It was important for us to include the Middle East in the single-player campaign, and we really thought there were some interesting game play opportunities around the story of T. E. Lawrence and the Bedouin rebels—true pioneers in guerrilla warfare.

134　THEATERS // THE MIDDLE EASTERN FRONT

THEATERS // THE MIDDLE EASTERN FRONT

THEATERS // THE MIDDLE EASTERN FRONT 137

A lot of fun settings and game play opportunities were explored for this theater. The addition of horses for multiplayer was an early dream that we didn't expect to be able to realize, but thanks to a dedicated team, we soon had our first play tests with the horse. It proved to be a game changer.

138 | THEATERS // THE MIDDLE EASTERN FRONT

THEATERS // THE MIDDLE EASTERN FRONT

140 THEATERS // THE MIDDLE EASTERN FRONT

THEATERS // THE MIDDLE EASTERN FRONT

ALLIED FORCES // THE BRITISH EMPIRE

ASSAULT

SUPPORT

MEDIC

SCOUT

The British Army of the era included a lot of ethnic diversity. We wanted to represent some of this in our multiplayer army and explored the options of including an Indian Sikh and a Nepalese Gurkha. Like all other armies, their uniforms and equipment would change over the course of the war, so we decided to go for what worked best visually.

THEATERS // THE MIDDLE EASTERN FRONT

SENTRY

CAVALRY

ALLIED TANK DRIVER

ALLIED PILOT

The Sentry was another power fantasy that we explored in early concepts. This character is based on the idea of a soldier putting on experimental armor and wearing a sniper mask for full cover while carrying a powerful machine gun. The first idea we had was to encounter this character in a boss fight in a single-player mission, and we were happy to see that it was also added as a special class for multiplayer.

144 THEATERS // THE MIDDLE EASTERN FRONT

JACK

FRED

Jack and Fred are the two Australian main characters of the Gallipoli mission. This episode was made by our DICE studio in Los Angeles, with whom we had close collaboration throughout the making of the game.

Their local concept artist made these sketches following the same template we'd been using in Stockholm for planning the character designs.

LIEUTENANT

146 THEATERS // THE MIDDLE EASTERN FRONT

The beach landing of Sedd el Bahr takes place the day after the first assault, so the scenery was intended to look gruesome and show signs of heavy defeat after the first landing attempt. The Gallipoli Peninsula provided tough vertical terrain for the soldiers. Villages, rough terrain, and Ottoman trenches were contested in those early days of the assault. Our version of Sedd el Bahr is somewhat exaggerated, but it captures many of the elements from this area.

The player should feel time passing throughout the level, so we wanted the initial landing sequence to feel like early morning with mist rolling over the landscape, and later transition into feeling like midday in the Mediterranean. For the ending, we tried to use the lighting to convey a sense of hope with a beautiful sunset amid the chaos around the player.

THEATERS // THE MIDDLE EASTERN FRONT

THEATERS // THE MIDDLE EASTERN FRONT

The 1914 British landing at Fao Fortress in the Persian Gulf was an early idea for a multiplayer level. We explored different themes for the level and several layouts of the fort to find something interesting. We had an opportunity to make a map of a coast with the potential for more boat game play, so we started looking at reference from these flooded areas around al-Faw close to Basrah. Our level artists would then do a quick block-out in the game so we could test the game play. It was one of the last maps we did, so getting it to feel right in a short time was of the essence.

150 THEATERS // THE MIDDLE EASTERN FRONT

THEATERS // THE MIDDLE EASTERN FRONT 151

152 THEATERS // THE MIDDLE EASTERN FRONT

This spread shows the variety of different concepts that we did for the game. Sometimes we help the 3D artists by doing object variations. It's a quick and easy way to try out concepts before starting to build assets. Other times, when we don't have specific tasks ahead of us, we have time to do paintings that can inspire the team and give the designers ideas for game play.

THEATERS // THE MIDDLE EASTERN FRONT

SHAPING OUR EDGE
KEY ART

The key art for the *Battlefield* series began to find its unique identity with *Battlefield: Bad Company 2* and has evolved with every game since. For each title, we face the challenge of creating innovations in the artwork while still staying true to the signature look that makes it unmistakably *Battlefield*. This is a behind-the-scenes look at how we came to reach the visual style for *Battlefield 1*.

Since establishing a key art style for the *Battlefield* games with *Battlefield: Bad Company 2*, we've followed a set of pillars to keep the brand consistent: there is the hero, be it a soldier or a vehicle, the heat signature that's become synonymous with *Battlefield*, and the world. When starting up a new project, we also explore what form the key art could take. When creating initial inspirational art, we try out themes, scenes, and actions that could translate into a key art concept.

The difficulty of *Battlefield 1* was challenging the preconceptions of the war and the era. We aimed to present a fresh, modern take on the hero soldier and the world while still rooting it in well-known themes.

The *Battlefield* key art reflects not only the art direction values of look and feel, but also the underlying themes of the game. Early explorations saw us using distinct graphical elements to attempt to convey the shift between the old, pristine world and the new world scarred by a mechanized war.

KEY ART 161

As the key art creation process spans the entire development of the game, we use the need for team presentation material to explore ideas. We dressed up team members in the same military equipment used in creating the characters and held simple photo shoots. This served as a basis for editing to give greater quality to the images and also enabled us to try out different visual techniques.

164 KEY ART

Over the years, we had gotten used to capturing action involving modern military accoutrements, and going from purposefully designed tactical equipment made from nylon, plastic, and composite materials to more simple gear made of canvas, leather, metal, and wood proved a challenge. We held a preliminary photo shoot with our chosen model, who is portraying the British Scout in both the key art and the game, to work out gear placement, lighting setups, and poses using capes and loose holsters and bags.

KEY ART

KEY ART | 167

Whereas previous titles in the series have shown the hero in a scenic environment, this time we wanted to have a clearer focus on the hero and a strong silhouette appearing amid the smoke while still capturing the epic scale of a behemoth.

KEY ART | 169

Using the high-quality material from the preliminary photo session we then explored the heat signature for *Battlefield 1*. Each *Battlefield* title's heat signature has a connection to both the logo and the game's theme: for *Battlefield: Bad Company 2* and the *Battlefield Vietnam* expansion we used fire, *Battlefield 3* had a pure light and digital distortion, and *Battlefield 4* had a digital-through-analog-TV distortion. For *Battlefield 1* we wanted a timeless logo and heat signature, using a long-exposure feel combined with a light-pollution bleed that could double as a thematic duality of old versus new, pristine versus violent.

KEY ART

Having settled on an approach for the key art, we went into a two-day photo session, employing experts in photography, weapons, and makeup, and utilizing the highest-quality cameras and lights with an overhauled wardrobe and an array of weapons from the era. We left with over seven thousand great photos that we could use to make comps and layouts before finalizing the art.

182 KEY ART